How to Paint
LIGHT

BARRON'S

How to Paint Light

First English Edition for the United States and Canada
published in 2011 by Barron's Educational Series, Inc.

© Copyright 2009 by Parramón Ediciones, S.A.—World Rights.
Published by Parramón Ediciones, S.A., Barcelona, Spain.

Original title of the book in Spanish: *Cómo se pinta la luz*
Text: Gabriel Martín Roig
Exercises: Gabriel Martín, Óscar Sanchís, and Gloria Valls
Photography: Estudi Nos & Soto, Gabriel Martín
English translation by Michael Brunelle

All inquiries should be addressed to:
Barron's Educational Series, Inc.
250 Wireless Boulevard
Hauppauge, NY 11788
www.barronseduc.com

ISBN-13: 978-0-7641-6454-5
Library of Congress Control Number: 2011923776

Printed in China
9 8 7 6 5 4 3 2 1

How to Paint
LIGHT

Contents

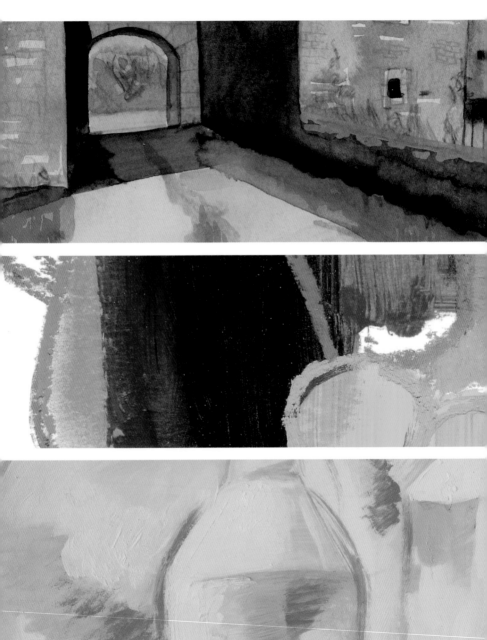

Introduction: Light as an Expressive Exploration

BASIC CONCEPTS OF LIGHT AND SHADOW, 8

▧ Distinguishing Between Light and Shadow, 10
▧ Light Creates Volume and Texture, 12
▧ Projection and Distortion of Shadows, 14
▧ Black and White, 16
▧ Block Shadows, 18
▧ **LET'S EXPERIMENT** Sketching Shadows, 20
▧ **IN THE STYLE OF...** Alexander Cozens, 22
▧ Shadows, Balance, and Rhythm, 24
▧ Light and Depth, 26
▧ Creating Monochromatic Shading, 28
▧ **EFFECTS** Wet Shading, 30
▧ Warm Light and Cool Shadows, 32
▧ **LET'S EXPERIMENT** Using Complementary Colors in Shading, 34
▧ **IN THE STYLE OF...** Honoré Daumier, 38

STUDIES IN SHADING, 40

▧ Shading with Tonal Values, 42
▧ The Importance of Learning Gradation, 44
▧ **LET'S EXPERIMENT** Modeling Effects, 46
▧ Receding Planes, 50
▧ Chiaroscuro, 52
▧ **EFFECTS** Different Light Conditions, 54
▧ Colored Light and Shadows, 56
▧ Blue in Light and Shadows, 58
▧ Sfumato, 60
▧ **LET'S EXPERIMENT** Light in an Interior, 62
▧ **EFFECTS** The Edges of Light and Shadow, 64
▧ Painting Darkness, 66

PAINTING LIGHT, 68

▧ Light Deconstructed: Rays and Photons, 70
▧ **IN THE STYLE OF...** Georges Seurat, 72
▧ Blinding Sunlight, 74
▧ White on Dark, 76
▧ **LET'S EXPERIMENT** Light on a Dark Background, 78
▧ Representing Artificial Light, 80
▧ Highlights and Bright Light, 82
▧ **LET'S EXPERIMENT** Reflections of Light on Water, 84
▧ **EFFECTS** Different Reflections for each Surface, 86
▧ **LET'S EXPERIMENT** Theatrical Effects of Reflected Light, 88
▧ **EFFECTS** Night Scenes, 92
▧ **IN THE STYLE OF...** Odilon Redon, 94

Light as an Expressive Exploration

The origins of painting are very much tied to the phenomenon known as light. Classical Greek authors thought that the action of light on a solid body was the origin of art. According to myth, a man with a piece of charcoal in his hand had the idea of outlining the silhouette projected on a wall by a person nearby. From that day, on which the first artistic representation was created, until now, the concepts of light and shadow have accompanied the development of painting as a symbolic element, a way of giving a representation credibility, and as a way to reinforce expression.

In art, the role played by illumination is almost always a deciding factor. The contrast of light and shadows is an active agent that expresses a great deal of information about the model being represented. It helps to define the orientation of the objects in space, to describe their volume, and to explain the form of the surface on which they rest. There is no question that light and shadow are vital in representing clear and authentic spacial reality.

Light and shadow are not only important instruments for making believable realistic representations; they also offer infinite expressive, dramatic, and compositional possibilities. They alter the way things look; they create confusion; they destroy outlines and deform objects, adding a great level of mystery. With so many options, the painter should not limit himself to reproducing the laws of the physical world as they are actually illuminated by light, but he should rather illustrate our reactions to these effects. One should learn to render a convincing image even when not a single detail corresponds exactly to what we know as "reality."

Because it is important for any artist to master light and shadow, this book is designed to study their effects and fullly explores the artistic and expressive possibilities offered by manipulating them.

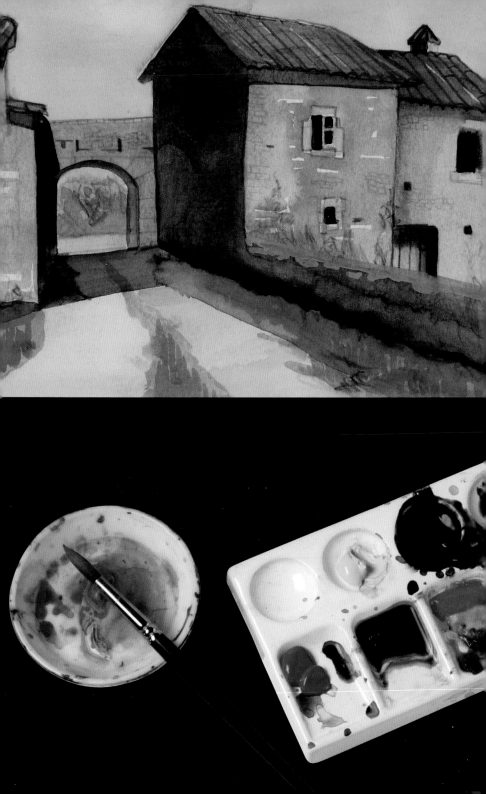

Basic Concepts of Light and Shadow

Representing light and shadow is a very complex task. Sadly, there are very few studies or technical texts explaining the impact of either on painting. This is because of the ephemeral and phantom behavior of the phenomena, which may not affect the layout or structure of the painting, but can notably alter its visual definition. The perception of form is conditioned by different varieties of light, contrasts, sharpness, and the blending of analogous shades. For this reason the treatment of light and shadow must become a fundamental subject for the artist. Perceiving, understanding, and representing values—that is, the light reflected by objects—is a basic step in the apprenticeship in any artistic medium.

Distinguishing between Light and shadow

Shadow is the part of any illuminated model that does not receive light directly, finding itself in that part of the object opposite the light source. It is an area of darkness where light is blocked. But how should it be seen? As a color? A space? An emptiness or a black hole? Or as a projection of the object that is blocking the light?

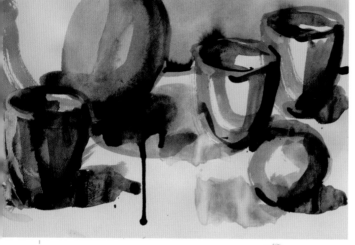

You must learn to distinguish the shadows in any model, since they are the fundamental clues for understanding volume and form.

Proper shadows are an inherent part of the object and help explain its form and its volume.

Projected shadows are basically a copy of the object and they situate it in space.

Categorizing the Shadows

Practice methodically observing the model and avoid painting it in a hurry. It is a good idea to first evaluate and categorize the shadows; that is, consider which and how many of them are the darkest, which are lighter than others, and how they mix together. Only later should you study the object's form and outline.

Distinguishing Two Types of Shadows

Not all shadows are the same; there are proper shadows and projected shadows. Proper shadows are found on the objects themselves and help explain their form, volume, and texture. Projected shadows are those that an object casts on a plane or on another object. Physically speaking, both are of the same nature, but perceptually they are very different. Proper shadows are an integral part of the object, while the projected shadow interacts with the surrounding space.

The area of light and area of shadow are separated by a line that is seen on the surface of the object, which we will call the separating line since it divides the two zones. If the light source is a point, this line will not be very blurred. If the light source is wider, the separating line will also be wider, blended, and blurred. It will look like a wide area that is half-lit, and cover areas that are not completely hidden from the direct light.

Light Creates Volume and Texture

Shading arises from the need to communicate the roundness of solid bodies, and later it is completed with highlights and reflections. Light and shadow play an important role in creating the sensory three-dimensional appearance of an object. They also serve to highlight colors and illustrate texture.

To understand how the effects of light strongly influence the rendering of volume, perform this simple exercise. Construct a figure composed of two diamonds facing each other covered with a uniform gray tone. You will perceive a flat shape. But if the right half of the figure is shaded with a gradation, there will be a consistent luminosity. Now it looks like a three-dimensional object, as if it were the sides of a cube.

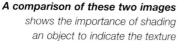

A comparison of these two images shows the importance of shading an object to indicate the texture of its surface.

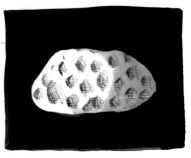

Shadows Help Us Understand an Object

When we normally view something, shadows are mainly guides to help us identify an object by its volume. In the space of a painting, shadows can become forms with meaning. Without them the eye would lose its sense of depth and relief.

Revealing Texture

When direct light illuminates an object uniformly, the small protrusions and extrusions of a surface with texture disappear because of the lack of contrast. On the other hand, lateral or oblique lighting creates large shadows that increase the textural look of an object. When light hits the surface of an object at an angle, it reveals the texture—the more exaggerated the angle, the more pronounced the texture.

A colored model without shadows communicates little information about its volume and texture. Shading is important for transmitting the tactile quality of the object.

Careful, meticulous shading can recreate the detail of the texture of any surface.

Projection and Distortion of Shadows

While proper shadows explain the volume of objects, projected shadows help to explain the surrounding space. Shadows are projected on surfaces and define them as flat, horizontal, uneven, or inclined. A sense of the space around the object casting the shadow is indirectly created by it.

To project the shadow of any object *simply draw a line that begins at the light source, passes across the edges of the object, and extends to the plane of the ground.*

Projected shadows communicate information about the source and intensity of the light and about the surrounding space. *A long shadow indicates that the light source is low (a); a shadow that widens shows that the light is very near (b); this shadow reveals an object behind (c); and the light casting this shadow originates from a high angle (d).*

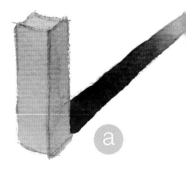

Projecting the Shadow

All projected shadows must adhere to the laws of perspective. They are determined by drawing rays of light that pass through significant points— the vertices in the case of a polyhedron, or the edges of an object. The intersection of these straight lines with a plane creates the outlines of the shadow cast on the surface.

The Angle of Incidence of Light

The greater the light's angle of incidence, the shorter the shadow. Contrarily, the smaller the angle between the direction of the light and the surface where the shadow appears, the longer the shadow will be. If the object is near the light source, the shadow will be larger than if it were farther away. The shadows that work best graphically are those cast at an angle between 30 and 60 degrees.

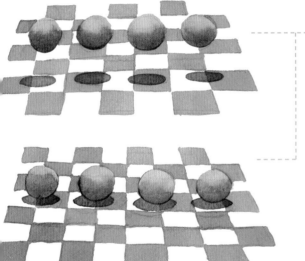

The projected shadow allows the model to be fully understood, and it can even change the position of the object that casts it. Here, if you ignore the shadows, the spheres are on the same plane as the checkerboard. Changing the position of the shadows causes the spheres to seem elevated.

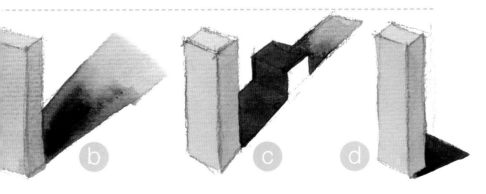

Black and White

Before delving into the complex world of light and shadow with the entire color palette, it's a good idea to begin with just two colors: black and white. These are not considered true colors; rather they represent the two extremes of illumination. Once you are familiar with the possibilities offered by gradations of these two values, it will be much easier to attempt more complicated and colorful approaches.

***Black and white** are the colors that best represent light and darkness.*

***Unequal mixtures of black and white** can create a tonal scale with the different levels of intensity of a shadow.*

Showing Light with Values

Images in black and white are not simply images that have been deprived of color. They deliberately represent tonality, form, and texture in an extremely explicit and suggestive manner. They are a good study in illustrating the presence or absence of light and the effects and textures that light creates, without the distraction of other colors that would make this simple process more complex.

Can Color Be Added to the Gray Range?

When professional artists work on monochrome paintings using only black and white, they usually add a bit of other colors from the palette to the gray tones. This allows them to expand the gray scale with warm and cool tones. Gray mixed with blue, ocher, green, or crimson will produce a series of tones that run from graphite gray to intense purple-gray.

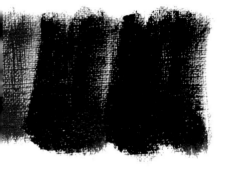

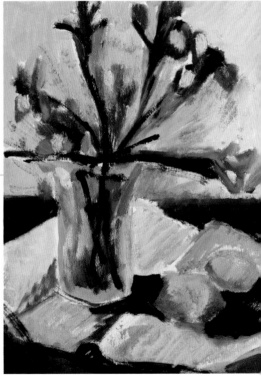

When working with black and white, the painter is strictly bound to the tonal range that these colors can produce. These technical limitations do not allow complete faithfulness to the model and the result will be affected by the values that can be created.

A neutral gray mixed with a bit of another color will give it greater warmth or coolness.

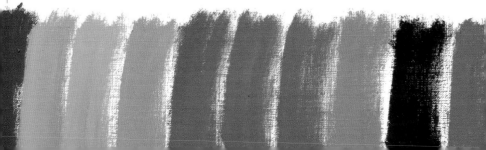

Block Shadows

Block shadowing refers to representing a model using large masses of a single value. At first glance, block shadows delineate what is directly illuminated and what is not illuminated and stays shadowed. It is a schematic approach to the general values of the scene, a way of using a general, uniform coloring to project the luminous structure of the model.

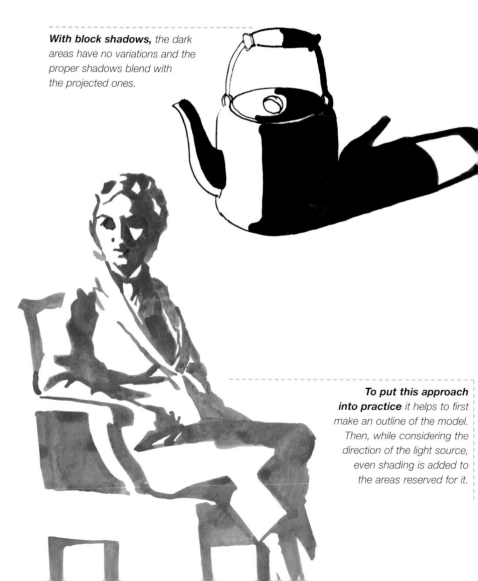

With block shadows, the dark areas have no variations and the proper shadows blend with the projected ones.

To put this approach into practice it helps to first make an outline of the model. Then, while considering the direction of the light source, even shading is added to the areas reserved for it.

Blocks of Dark Color

First observe the model, and study the form and edges of the shadows on it. Then paint each of the areas of shadow with a single uniform color (usually gray, black, brown, or blue). This way, the shadows are made in the form of blocks of dark colors that are clearly differentiated from the illuminated areas indicated by the initial white color. No intermediate tones appear between the areas of light and the areas of shadow.

Antagonism Between Lights and Darks

These representations are antagonistic images, where white and black interact as equals. The shadows are full and show the greatest possible light contrast. That said, it is not clear if we are looking at a dark object illuminated by a strong lateral light source, or at a white object that is partially shaded. The pronounced conflict between light and shadow imparts a strong dramatic tension to these works.

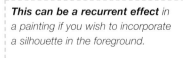

__Block shadows__ are not necessarily related to monochrome painting, they can also be incorporated in colorist compositions.

__This can be a recurrent effect__ in a painting if you wish to incorporate a silhouette in the foreground.

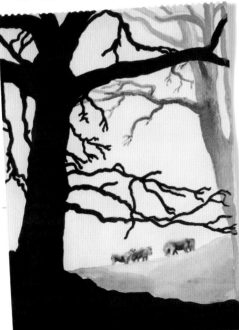

Sketching Shadows

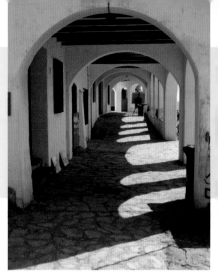

The model is an interior passage with arches. The light that penetrates the openings from the side projects an interesting play of light and shadow.

① ②

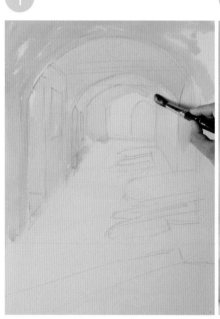

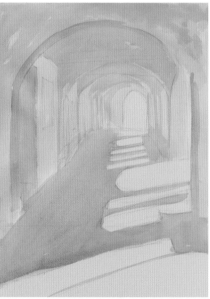

1. The drawing of the architecture is done with a 2B pencil. A quick overall wash of light gray is applied to all the shaded areas.

2. This first grisaille is allowed to dry before overlaying a second, slightly darker wash. The areas of light and shadow are now clearly delineated by the two washes of gray watercolor, to which was added a very small amount of blue. This will serve as the basic guide of reference.

In this first exercise painted by Óscar Sanchís, the shadows are sketched in with watercolor washes. This approach is a relaxed investigation of the relationship between the illuminated and shaded parts of the model. The point is to illustrate the light in the scene using a very limited range of just three or four tones. In doing this, it becomes necessary to create a series of references that have a hierarchical coherence equivalent to that which we see in reality.

4. The darkest contrasts are left for last. Do not use absolute black, but rather a shade of gray that has sufficient contrast. A bit of brown can be added to this gray to give it a slightly different tone than the previous washes.

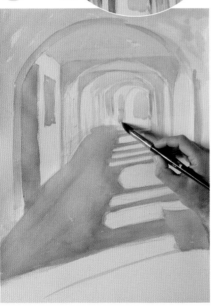
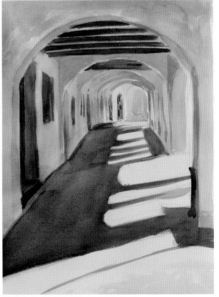

3. *The gray tones are organized into a range from light to dark. There are no abrupt changes; the new grays are progressively laid over the previous ones so as not to lose control of the painting.*

5. *The finished work accurately reflects the feeling of the light in the original architectural scene. It was not necessary to use a vast range of values to catch the effects of light. The areas bathed in direct sunlight have been left white on the paper with no washes at all.*

Alexander Cozens
(1717–1786)

Alexander Cozens constructed his landscapes through the perception of shadows and contrasts of light.

Villa Near a Lake *(c. 1770)*
This artist advised against the traditional method of highly detailed drawings; he argued for the use of a quick relaxed sketch that would open up new possibilities. Cozens' new method encouraged freshness and inventiveness and resulted in original representations of landscapes. It was an empirical method, which used a loose, almost abstract brushstroke technique that stimulated the artist's imagination and promoted the use of intuition in landscape painting.

PERCEIVING

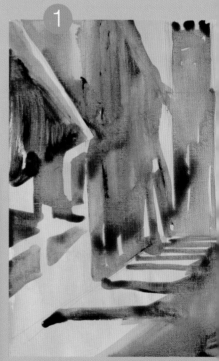

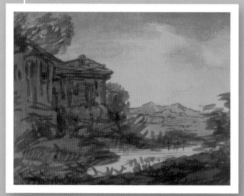

1. Using acrylics, Gabriel Martín attempts to imitate the constructive watercolor process of Cozens. He begins by painting the first brushstrokes in a very diluted burnt sienna over a background colored with yellow ocher. The most illuminated parts of the facade and sky are left uncovered.

Today this British artist is not known for his large format works, but for his theories and special method of indicating shadows, which directly influenced the Romantic painters of the nineteenth century. Cozens was the author of several texts where he advocated the use of abstraction as a starting point for his compositions. In his book *A New Method of Assisting the Invention in Drawing Original Compositions of Landscape* (London, 1785), he proposed the method of using "blot" drawings, used to construct a model based on shadows.

H T A N D S H A D O W

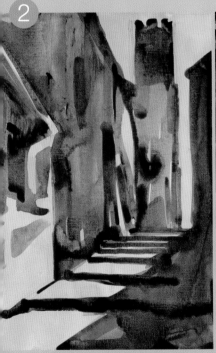

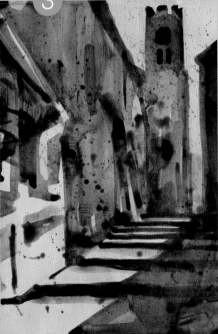

2. When the first layer is dry, a new wash of a more intense brown is added over it to make it darker. The new brushstrokes are used to darken the bell tower and the steps, and to add volume to the facades on the left.

3. The most pronounced and contrasting shadows are darkened. These last washes create openings on the walls of the buildings, suggest textures, and indicate some architectural details. The sketch is finished with light spattering in the center of the painting to add an informal atmospheric touch.

Shadows, Balance, and Rhythm

Shadows are not isolated autonomous elements, they are one of many parts that form a complete work of art. All visual representations involving light and shadow are perceived as a composition of diverse tones and contrasts distributed across the surface of the work in an organized manner. The artist can modify the distribution of shadows to make his painting more expressive and rhythmic.

*Often, the shadows of a model seem **compact** and irregularly distributed, creating confusion and imbalance.*

The artist can manipulate some shadows by leaving spaces between them, to balance and better organize the composition of a painting.

*An ordered distribution of **shadows** with intervals of light among them, much like a checkered surface, reinforces the rhythm and order of a composition.*

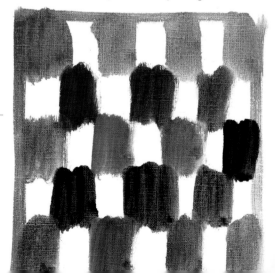

The Rhythm Factor

Rhythm is the periodic factor, and refers to the way the shadows are repeated and interspersed among the illuminated areas. There are pauses and interruptions between them, and there is a balance and similarity in the forms. Consciously repeating the spatial intervals at different frequencies adds a musicality to the visual reading of a painting and creates the feeling of visual movement.

Organizing the Shadows

You must learn to use your judgement when distributing the light in the model—you can even "fake" some shadows to add more rhythm to the painting. In other words, real shadows can be manipulated, or imaginary ones can be added to balance the spatial organization of your painting. Any composition can be improved by emphasizing the space occupied by the main and secondary shadows.

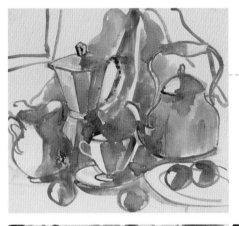

Here the shadows are large and close together. *They create confusion and pay no attention to rhythmic sequence or any kind of order.*

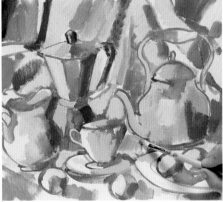

With a new redistribution of light and shadow, *the model now looks more attractive. The rhythm factor keeps the model from becoming excessively static and boring.*

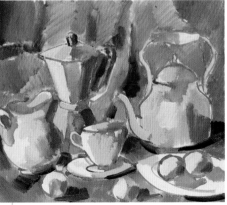

The artist can modify, *and even fake, the distribution of light in the model for expressive purposes.*

Light and Depth

Gradating and altering light are closely associated with the representation of depth; however, they are not always used in the same way. Contrasted light is used to avoid confusing different planes when the model is in the foreground, while gradations are more related to rendering atmosphere in a landscape.

When an area of uniform tone appears on a white surface, psychologically we tend to feel that it is receding, and it may even be interpreted as a hole or opening.

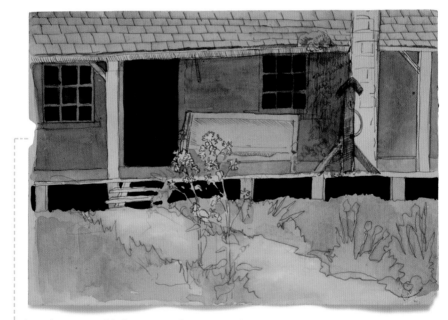

In a close-up model, the nearest planes are represented as areas of light while the openings and more distant planes are usually shaded. Notice the facade:

the spaces that advance toward the viewer are lighter in color, and those that recede are more shaded.

Creating Depth with Gradations

When reproducing a landscape, gradated shading is the best way to get the effect of fading that is caused by light in the landscape as the planes get farther away. Lighter color is synonymous with greater depth.

In a landscape, gradation is the key to representing the light that loses color and becomes fainter in the farther planes.

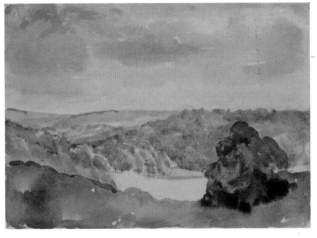

Particles of water and dust in the atmosphere are illuminated by daylight and they are what causes the farthest planes to look lighter and bluer.

The contrasts between light and dark are the references that cause a viewer to perceive distance. The foreground is where the objects should appear darker and more detailed. Any element located here (trees, rocks, a post) should be clearly identifiable and painted very dark—contrasted, like a shadow or silhouette.

Creating Monochromatic Shading

The differences between light and shadow, and contrasting light in a single color can be represented using modeling techniques, or through the progression of values of the same color in different intensities. When working with washes, the most common colors are black and Payne's gray, although browns and blues may also be used.

Two different ways of handling monochromatic shading: one is based on a gradated wash (a) the other establishes a tonal scale (b).

When shading with a single color, it is a good idea to begin with quite transparent washes, and progressively darken them by adding more paint. Paintings done in black are somber, but they have very intense contrasts, which impart great depth to the works.

Black and Payne's gray are the most commonly used colors when doing monochromatic shading. A tonal scale can be created that will match the progressively darkening shadows.

The Darkest Tones

Don't go to extremes with tone—that is, don't assume that the lightest point of light should be white and the darkest black, and that the rest of the tones lay in between. This would be an error, since often the lightest tone in a scene is a medium gray, because of lack of overall light. In fact, pure white is very rare, as is absolute black.

Monochromatic Work with Adjacent Colors

It is not necessary to limit yourself to a single color when making a monochromatic painting. Just as effective and richer is the use of a range of colors that are adjacent on the color wheel. For example, if you are going to paint a green wash, it's best to use a wide range of greens that vary in tone and brightness.

When you use more than one variety of the same color, in this case green, the result is much richer. The illuminated areas are painted with the yellow-greens, and the shaded areas are represented with bright greens or blue-greens.

In monochromatic shading you don't need to stick with one single color. You can work with adjacent contrasts, that is, greens of different tones and intensities.

EFFECTS

Wet Shading

This refers to painting the shadows of a drawing directly with a brush that is well charged with very diluted, liquidy, paint. Each application done this way will be large and probably uneven, drippy, and runny. All this translates into a type of shading that is agile and expressive. This technique is even more effective if you work on a dampened piece of paper, taking advantage of the spreading and dispersion of the random brushstrokes.

To better understand how liquid shadows are applied, let's compare these two representations. In image (a) the drawing is simple, with no hesitation, and the somewhat conventional coloring stays within the edges of the drawing. In image (b) the drawing is shakier and more uncertain and the colors have a life of their own, flowing over the edges of the object. The second example is what we are talking about in this section.

This technique allows you to achieve very expressive results, with effective albeit stylized shading. Imprecision and uncontrolled feeling free artist and viewer alike from the straightforwardness of a typical painting.

The Importance of Incertitude

All knowledge carries with it the possibility of error—don't reject this idea; rather take advantage of uncertainty and use it as an expressive or poetic element.

Any evaluation of a representation of a real model implies reflection, doubts, criticism, and corrections. Therefore, it is necessary to understand a drawing as a system, or an instrument of questioning and exploration, where inexactness and uncertainty can be accommodated.

The wet on wet technique has many variations, but in general it refers to a drawing made with a material that is diluted on a wet support, allowing for the fusion and mixing of colors.

Liquid shading can create an imprecise look to the shading of any drawing. It is used as a direct tool of creative thought. In other words, it is a technique that celebrates creativity and expressiveness at the expense of restraint and an academic approach.

Warm Light and Cool Shadows

The most common classification of colors is the division into warm and cool types. Yellow, orange, and red colors belong to the warm part of the color wheel, and violet, blue, and green colors belong to the cool. In strong light, illuminated features seem fiery; therefore, they can be resolved using the warm range of colors: yellow, orange, and red. The shadows, meanwhile, relate to the range of cool colors.

Generally, the illuminated areas of a model *are painted with the warm range of colors. These areas are the recipients of direct sunlight.*

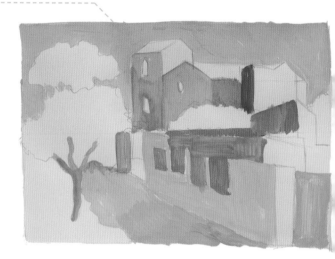

The shaded areas, *on the other hand, are associated with the cool colors. Blue and green psychologically represent the absence of light.*

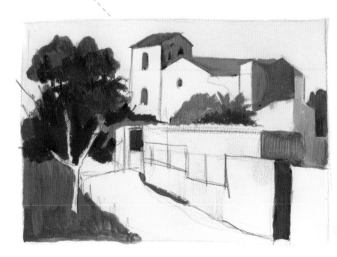

Near and Far Colors

Warm colors indicate nearness, while cool colors are linked to the distance. These associations come from the fact that the sea and the sky are usually farther away than the ocher or reddish ground. This way of perceiving distance exists also because far planes in a landscape are generally bluer than the closer ones.

Once you understand the way light is associated with warm colors and shadow with the cool ones, put this knowledge into practice. Light is always represented with yellow and orange tones in this pine forest, while blue and green do the same with the shadows.

When painting a landscape, the colors that appear in the foreground have a warmth, while in the farthest planes the colors belong to the cool range.

Using Complementary Colors in Shading

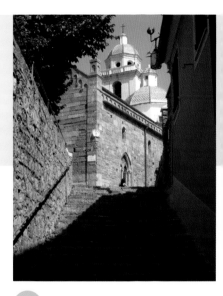

1. The first pencil sketch is completely linear, without any shading. This step plays an important role when you are attempting to represent architecture. The drawing may be a bit deformed, but it should maintain coherency.

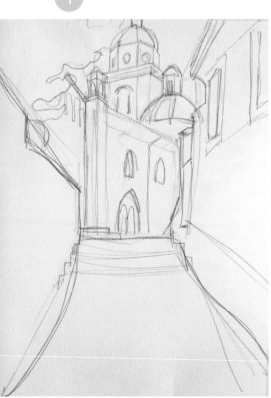

①

②

2. The first strokes of thick oil paint are applied to the illuminated areas. Red is applied to the trees, and varied shades ranging from ocher to light yellow are used on the buildings.

The use of contrasting complementary colors for shading is based on the idea that the proper and projected shadows of any object will invariably contain the complement of the color of the object itself. Therefore, many artists traditionally use pairs of complementary colors to increase the spectrum of colors in the model. For example, when painting an urban scene they might use two colors, red and yellow, in the areas of light and their complements, green and violet, in the shadows. This exercise was done by Gabriel Martín.

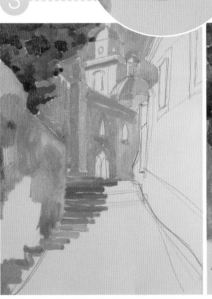

4. The stairs that receive direct sunlight are painted with reddish and yellowish tones, alternating the two colors. They are rendered in a distorted and exaggerated manner to make a strong personal statement.

3. Green, which is the complement of red, is used for the shadows of the leaves of the trees. When they are placed together both colors seem brighter. The sky is painted with a very light green, and the facade of the church is filled in with new shades of yellow.

5. Since the complement of yellow is violet, it is used to paint the doors and windows of the church. Violet is also used to go over the main architectural features.

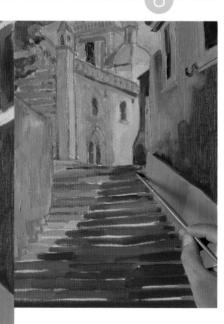

6. Now it is time for green to make its appearance on the shaded wall on the right. The different shades are quite toned down and not very bright. A few touches are also added to the church, which will help all the colors in this exercise become more cohesive.

7. The stairs in the middle of the shaded street are painted with new mixtures of green and violet. The brushstrokes should be horizontal and complete the stairs that were begun in red and yellow.

8. Be careful where red or yellow meet green or violet. When two complementary colors mix in equal proportions they produce a neutral gray or brown—this effect should be avoided.

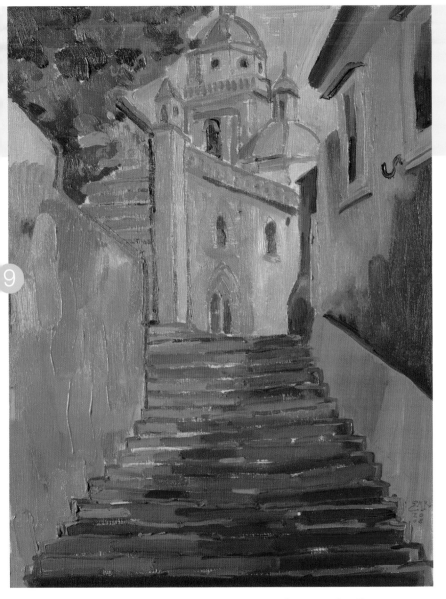

9. The green on the nearest steps is brightened and thin red lines are painted between the stairs. With this finishing touch, the painting is completed. With the illuminated areas painted in yellow tones, and the shadows in green or violet, a strong sensation of light and temperature, between the warmth of the sun and the coolness of the shade, is evoked masterfully.

Honoré Daumier

(1808–1879)

Daumier was a Realist painter who was very interested in the action of light on the human figure. This figure has a stylized physiognomy and light is used to outline and model his appearance.

The Washerwoman *(1860)*
In Daumier's paintings the people are rendered as compact, somber masses in grays and browns. Occasionally a silhouette is created by the contrast of a background bathed in a strong light.

Honoré Daumier was a great chiaroscuro painter.

1. Gabriel Martín reproduces this same silhouette effect in a more familiar scene. The process is simple. First the model is drawn on a dark background in pencil. Then it is traced in ocher with a fine, round brush.

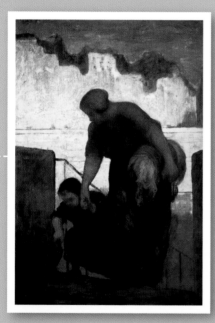

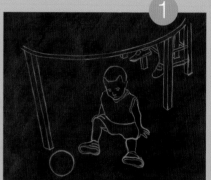

2. The skin tones are painted in browns that are darker than usual. When the rest of the figure is painted, the colors must be darkened with gray, brown, or violet. Our goal is to create Daumier's silhouette effect, so the figure must be darker than usual.

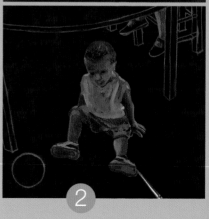

Daumier's style foreshadowed Expressionism which evolved later. The dark colors in his figures are an homage to Baroque style, in particular Rembrandt and the Spanish painters of the seventeenth century.

3. Once the figure is finished, and the feet peeking out from under the table are painted, the background is filled in with a very light yellow. Next all the forms are outlined. The legs of the table and chair are left the same color as the background. A bit of sienna is added to the white as it moves down the surface of the painting.

4. The background is covered with light yellow. The lower part should be slightly redder, making a subtle gradation. Since the figure of the child is surrounded with such a light color, his coloration seems even darker and the desired silhouette effect so common to Daumier's paintings is successfully produced.

Studies in Shading

Now that you have analyzed the main psychological, perceptional, representational, and compositional aspects of shading, it is time to learn to construct it and gradate it. You must learn to determine the kind of shading that should be applied in each situation to help improve the visual comprehension of your subject. Should its edges be represented using contrasts or accurate tonal values? Will you simulate the third dimension by modeling, chiaroscuro, or with other graphic techniques that help develop the many kinds of shading? We will also explain the advantages of choosing the appropriate artistic medium for each approach since each medium has its own personality and requires its own specific techniques and solutions.

Shading with Tonal Values

Familiarity with tonal values is important when learning to perceive the subtle changes in tone that can be seen in shadows.
To understand them, shadows should be interpreted as having a tonal scale with a succession of uniform areas of color ranging from lightest to darkest. This is a popular method for developing a facility for painting with a wide range of colors.

***When light strikes a round object,** for example, four areas can be distinguished: the two outer zones which are more illuminated and another two which are more shaded. In between is a medium tone that acts as a transition. This treatment of light based on tonal scales, in which each zone is assigned its own color, is commonly used in art to produce a sense of relief and depth.*

***When working with tonal values,** each value should be differentiated from the others. This is very useful, especially when using a palette of monochrome colors.*

A Few Values Are Enough

Creating convincing shading requires learning to combine shadows into large groups of values. Applying the greatest number of possible tones is not the goal; the model should be reduced to five or six different values of intensity (including the white of the support) which get distributed in a way that resembles the actual shadows on the subject. Working with too many values reduces precision and can cause a certain amount of visual dissonance.

Tonal shading is useful for presenting shadows in a more structured manner. This should be considered a useful graphic approach.

In a watercolor based on the use of tones, a value of level of intensity is assigned to the color in each zone. This way the painting is built up as if it were a structure where each tonal piece contrasts or complements the one next to it.

The Importance of Learning Gradation

The impression of light is based on gradients or gradations. They perfectly define the incidence of light on a curved surface, which is useful when communicating things like the roundness of solid bodies or the folds of drapery. It is very important to develop gradations correctly so that they accurately illustrate the volume of surfaces.

Gradations can convert a form that is seemingly flat into an object with volume, through the different distribution of light on the form's surface.

Modeling is directly based on gradating, but is achieved by completely blending the colors. The colors are treated very carefully so that the brushstrokes disappear, and this makes the study of the light more believable. The final application should be made with a soft brush to eliminate any sign of the previous brushstrokes and perfect the modeling.

Gradating Volume

The clarity of a color changes from the effect of light on curved, cylindrical, and spherical surfaces to show a range of tones from lightest to darkest. This is represented with gradations, that is, blending two different values or colors until the line between them disappears.

Gradating Overlapping Objects

When the light on several overlapping objects is physically identical, it is very easy to differentiate one from another by using gradations. If the surfaces of the objects are carefully reinforced with light gradations, any possible confusion of their outlines is avoided and the objects will not seem to be stuck together.

Differences in light are useful for separating overlapping objects. It is common to introduce gradated shading when trying to show an interval of depth between objects with nearly identical lighting. Again, the shading is used to emphasize the overlapping.

Modeling Effects

The selected theme is simple: bowls of fruit in a corner of a kitchen, illuminated by the light shining through a window, softened by a curtain.

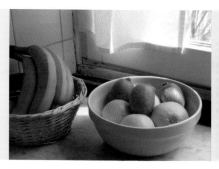

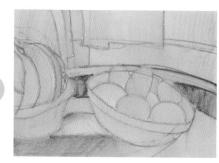

1. *The preliminary sketch is made with a thick stick of pastel instead of the typical pencil or charcoal. Then the lines are diluted with a brush charged with turpentine to create a base of light color that softens the impact of the white of the canvas.*

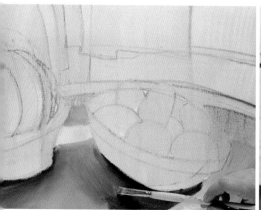

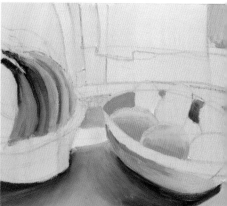

2. *The marble counter is indicated with very light gray diluted with turpentine, and the areas of shadow are painted using the same gray modified with a bit more black and some blue.*

3. *The bananas are painted with curved brushstrokes that alternate yellow and medium green. Gradations from yellow to red are made on the oranges, and from ocher to orange-sienna on the fruit bowl. This illustrates the gradients of light on the curved surfaces.*

The principles of gradation and modeling will be put into practice to illustrate the subtle gradation of light on spherical and cylindrical surfaces in this still life painted by Gabriel Martin. The very static composition is given a fresh, attractive mood by exaggerating some shapes and increasing the color saturation. Oil paint is the best option for creating the modeling effects because its slow drying time allows you to paint over the layer of colors until arriving at the right representation of light on the smooth curved surfaces.

4. *To make the curtain's gradations, various gray tones are applied to create vertical stripes that touch each other. The tones are then blended with a dry brush to complete the effect.*

5. *Instead of being painted white, the window frame is made up of gradations of different gray tones. Some of them have a bluish tendency, others yellow, green, or violet. The paint should be thick and applied quickly and loosely.*

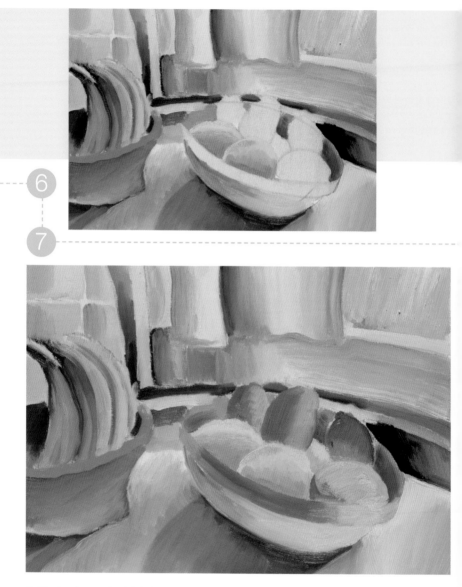

6. The basket on the left is finished with a combination of ocher, black, crimson, and cinnabar green, all well blended with each other. Very light earth tones are added to the grays on the window. Working on a wet surface allows you to easily integrate the new colors with the underlying ones.

7. The fruit in the center of the painting is finished. Each piece was resolved with gradations that clearly illustrate the distribution of light on its surface. No more paint needs to be added to the picture.

8. Now it is time to soften the modeling even more. A soft brush is used for this, lightly stroking each surface to eliminate, as much as possible, all signs of the brushstrokes.

9. In this finished piece you can see how the gradations look softer. The final modeling with the soft brush gives all the surfaces a velvety look, more in accord with the soft, low-contrast light that illuminates the real model.

Receding Planes

If you take a good look at a landscape, you will notice that the succession of planes in a work of art is created by the perception of light and dark zones that are behind each other. A fading effect results when the arrangement of planes seem to be behind one another as they recede.

A landscape is not best represented by a simple gradation of colors. It is better to jump back and forth between light and shadow—inserting darker planes of color to stagger the values can accomplish this.

The color sketch could be stylized as shown below. The areas of brightest color are inserted between and balanced by bands that are darker and more shaded.

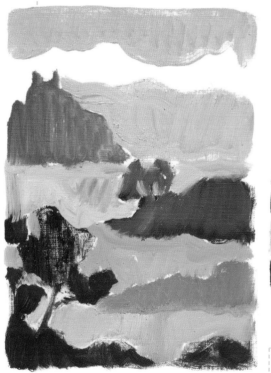

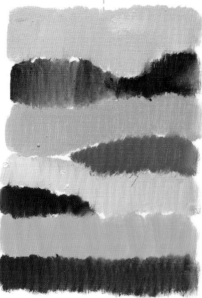

The darkest band of color feels pushed forward, while the ones that are lighter tend to move farther away. By altering the brightness of each plane, the landscape becomes balanced and more interesting.

Planes of Light and Color

In landscapes where clarity dominates, the liveliness and brightness of the light may run the risk of appearing too strong—to compensate for this the artist should use dark planes to control the composition and to organize the space. Rather than break up the painting or fade out the landscape with a simple gradation, the light of each of the planes is modified to scale the intermediate values and impart an expression of depth to the work that is more exciting to the viewers.

Balancing the Landscape with Contrasts of Light

This play of light and dark planes creates an imaginary space (it does not exist in nature), but at the same time it is real (it exists for us as viewers). The artist must construct it to balance the light of the landscape. Light contrasts help create contrasts in distance, but so do the *repoussoirs*, or objects placed in the foreground that help make the background seem more distant. Of course, for this technique to work there must be a strong contrast between the foreground and the background light.

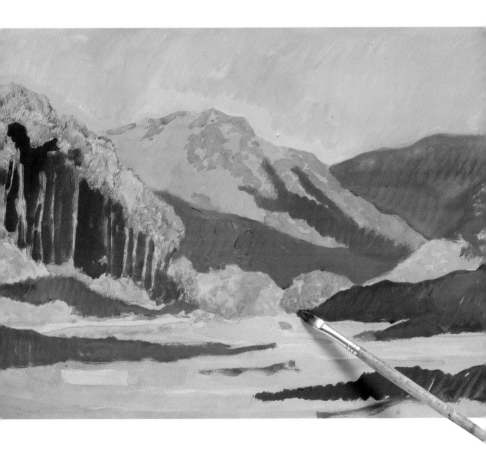

Chiaroscuro

This art technique is characterized by the use in a painting of strong contrasts between the illuminated volumes and the shaded ones with the goal of emphasizing particular elements. The strong contrast that is created between the parts makes this technique especially appropriate for evoking dramatic scenes.

Impact of the Light

Chiaroscuro is added to the scene to emphasize the volume of objects through the incidence of light on their surface. The areas of strong light make objects look like they are emerging from a generally dark background. It is as if the darkness suddenly opens up thanks to the impact of the light. The use of chiaroscuro, especially if extreme values of black and white predominate, adds drama to a scene.

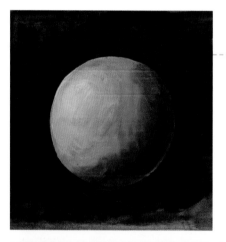

Chiaroscuro lets you model and emphasize the character of the form, softly blending it with suggestive transitions.

The objects that emerge from a completely black background seem more brightly lit through the effect of simultaneous contrast.

Quick Transitions

Technically, chiaroscuro is created by working with gradations of a tone—on one hand gradating towards the maximum light, and on the other, toward the darkest shadow. For the chiaroscuro effect to be complete, the transition from light to shadow must happen fast, which means avoiding a wide use of the middle tones.

Shadows Blending with Backgrounds

Dark shadows destroy the form, not only because they hide important parts of the object, but also because they break the continuity of the curvature with very distinct dividing lines between light and dark. In this way they stimulate the sense of sight by blithely disfiguring familiar forms, and enhancing them with violent contrasts.

To represent the figure dramatically, *use abrupt contrasts, or even obscure it with ambiguous half-lights that blend it into the background.*

Different Light Conditions

The quality, intensity, direction, and coloration of light are the factors that determine the nuanced appreciation of a given represented object. Even a minimum change in any of these factors translates significantly to the object since it will acquire a new expression that is unique and different. Before confronting the problems of light on a model, it is a good exercise to study the effects of each one of these conditions, working with the same very simple model.

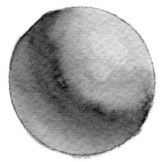

Natural light is usually bluish and comes from above. *On objects it produces a soft gradation of shadows from light to dark.*

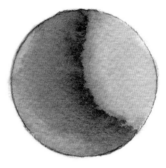

This sphere receives an intense lateral light from an artificial source. *Its shadow is more gray and contrasting than one caused by natural light would be.*

Light coming from behind the ball, *from a slightly elevated position, illuminates the upper area and leaves the rest in shadow. This can be softened with a gradation.*

The sphere seems brightly lit from below with direct or reflected light. *This illumination is used rarely, but it is ideal for creating unusual images.*

The light from an electric lamp or from a setting sun *becomes increasingly warmer and it has an obvious yellow tint.*

During a sunset the light turns an orange color. *It is not as strong as during the rest of the day, and the areas in shadow become a deeper blue.*

During a sunrise the sky becomes the only source of natural light. *It is a very soft blue light with delicate shadows.*

When there is not any source of direct light, reflected light becomes the only source of illumination, *and because of this it projects a strong blue.*

When there is a colored screen near the ball, *in this case red, the light reflects from the screen onto the sphere creating an interesting chromatic effect.*

On a cloudy day grays will appear on the lighted object, *due to the reflection of the grays in the sky. The shadows are very blurry and the colors very faint.*

Colored Light and Shadows

There is a tendency to assume that shadows should always be represented with grays, browns, blacks, and other dark variants. Be careful; diminished light does not necessarily mean that the colors in the painting should be darkened. The differentiation between the different amounts of light and darkness can also be achieved by using contrasting colors.

In this shaded apple, *the zones with shading are represented with a gray mixed with a little of the apple's red tone.*

In a colorist interpretation, *the shadow of the apple is represented with a complementary color—in this case, green, the complement of red.*

Shadows can be painted with blue, green, or violet colors. *It is important that these colors not be dark, but rather saturated and of a medium intensity. Then, if the illuminated areas are painted with bright, warm colors, the lighted areas will seem hot and glowing, and the model will become a festival of color.*

Value Painting and Colorist Painting
In value painting the color of a shadow is based on the color of the object, but it is a darker version. This principle, however, is not useful if you are trying to paint a colorist work, where the darker colors are replaced with others that are lighter and more saturated to indicate the shadows.

Shadow Color Is Dictated by Light Color
When the light that illuminates the model is in color, it causes the appearance of complementary colors in the respective shadow. When a body blocks the source of light (which in this case has quite a strong red and green tendency) the other two colors on the palette are mixed to create a shadow of a counter color, generally complementary, which creates a relative effect of compression and tension.

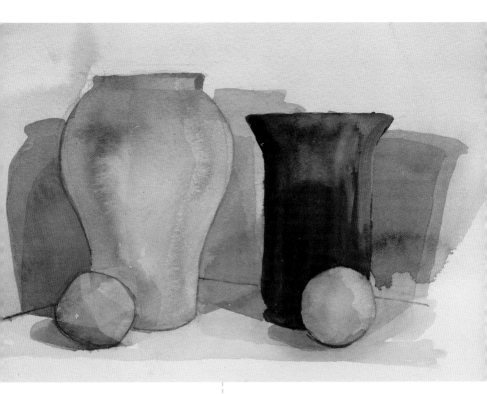

The characteristics of the light determine the color of the shadow. A model illuminated with red or green lights will create orange, green, or yellow shadows.

THE SUBJECT

Blue in Light and Shadows

Impressionism sparked an interest in pure and vibrant colors and relegated the effect of chiaroscuro to a secondary role. The colors black, Payne's gray, and burnt sienna were temporarily set aside to work with a much more illuminated palette.

The presence of blue and violet colors in the shadows enlivens the coloring of the watercolor and creates a welcoming atmosphere for harmony.

Light blue is also sometimes used to infuse light. Here we used small dabs or strokes of blue to create twinkling vibrations of color to represent the atmosphere of the scene.

Darkness Is Blue

Rejecting the modeling effect where tones pass from light to dark, the Impressionists played with the traditional order of tones. Their shadows, instead of tending to be brown, moved toward blue, and they were close in value to the colors of the lighted areas. The Impressionists agreed that when light was not very intense it cooled and consequently became bluish or even violet, similar to landscape colors at dawn.

Immobilizing Light

Many artists that work outdoors begin by painting the shadows of the model with flat washes of blue paint. This way of starting a painting helps to create the layout and correctly distribute the light. Furthermore, it is used to immobilize the light of the landscape. When painting outdoors the shadows change their size and appearance as time passes, so it is necessary to start by fixing them in place. The artist can then later resolve the final colors at a more relaxed pace without worrying about the changing light.

Many watercolorists that paint outdoors immobilize their shadows with blue washes before beginning to paint.

The choice of blue for shadows can be explained by the fact that it is the complement of the range of oranges, pinks, and yellows that are used to paint the areas of light.

Sfumato

Sfumato is used when a model is encountered under certain specific light conditions, for example, under a hazy atmosphere in fog or in rain, or under dim light. Outlines and sharp edges are avoided with sfumato.

Blending the Edges

In a scene with faint, weak, or screened light, sfumato reduces the contrasts and intensity of the shadows and highlights. A model that is perceived with little definition or in a nebulous way should be represented similarly—blurred and without sharply defined forms. This means paying less attention than you normally would to objects that are clearly illuminated or that have a strong chiaroscuro.

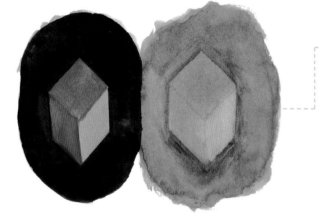

The form on the left has strong contrasts and well-defined edges. *The one on the right is blurry, monochromatic, and has an imprecise outline with little contrast.*

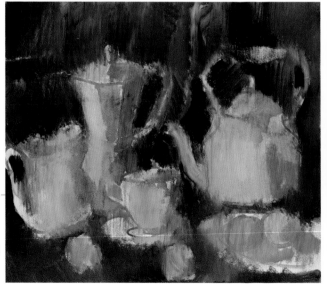

With sfumato, contrasts are reduced and highlights disappear, *as do the areas of intense light.*

Grain and Noise

Sfumato also causes the texture of objects to lose their detail so that the surfaces look unfocused, with little contrast of light and shadow. Some artists enhance this effect by working on textured surfaces that break up the brushstrokes and impede the creation of solid contrasting lines. To define this effect of grainy painting or brushstrokes that break up the form, artists have borrowed a term from digital photography. The effect is called "noise." Therefore, increasing the noise in a painting emphasizes the blurring.

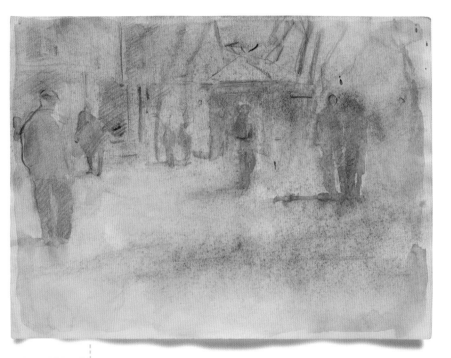

The faint light of rainy days demands sfumato. Here the figures do not need to be separated from the picture plane by using very pronounced brushstrokes.

Very intense light on an object can be represented with a whitened sfumato to cause the loss of contrast. The effect of "noise" is heightened with the brushstrokes.

Light in an Interior

1. A drawing is made with a 2B pencil. The line should be barely perceptible. The darkest areas of the interior are covered first with very diluted violet and gray tones.

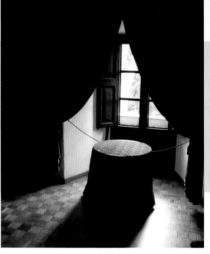

Light penetrating the interior of a room through a window creates strong contrasts and expressive, strong shadows.

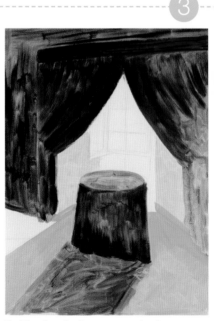

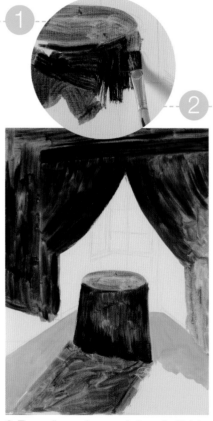

2. The earlier washes are darkened with later ones. The darkest areas on the wall and table are covered with a black that is not opaque, giving great depth. In some areas, the black is transparent and allows the underlying violet to show through.

3. After the shadows are resolved very synthetically, the light on the floor and wall is addressed with a light ocher and yellow. The use of the latter color, which is the complement of violet, assures us the greatest possible contrast.

Natural light that penetrates an interior causes very strong, dramatic contrasts of light and shadow. These play a major role in the perception of objects. Colors can be seen in the most illuminated areas, but the shadows are simply a collection of dark areas that vary only via light reflected from nearby surfaces. Here we show you how to resolve a corner of a room with acrylic paint, recreating the atmosphere and paying close attention to the direction and the distorted effect of the cast shadows.

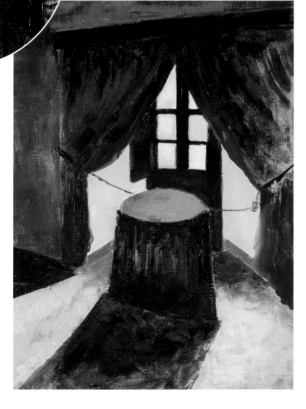

4. The areas of light are worked with very opaque, saturated paint. Red is spread on the table with a metal spatula. This same tool creates somewhat textured applications on the curtains and floor.

5. The spatula is used to apply orange and burnt sienna to the floor at the base of the illuminated wall. The window frame is darkened with a mixture of black and Prussian blue, and it is also used for gradating the shadows of the table and the curtain. Glòria Valls then uses a fine round brush to paint the final details.

The Edges of Light and Shadow

This study is based on an object that projects a solid shadow on an illuminated blue floor.

Here, the shadow is solid and the line of its edge is very contrasted. *This happens when the light source is very intense.*

If the model is illuminated by several light sources, *the outline of the shadow will appear twice, forming a tonal scale.*

When there is a screen between the object and the light source or the light *is far away, the projected shadow has softer edges that look somewhat blurred.*

When the object that projects the shadow has ramifications, *like a flowering branch, the projected shadow looks fragmented, with points of light within it.*

There are different ways of interpreting the edge or outline that exists between lighted areas and shadows: block outlines, solid linear shadows, broken or blurred shadows that may even include reflections or highlights, and more. In this glossary we study that precise border or edge—how to recognize it and how to approach it in various situations.

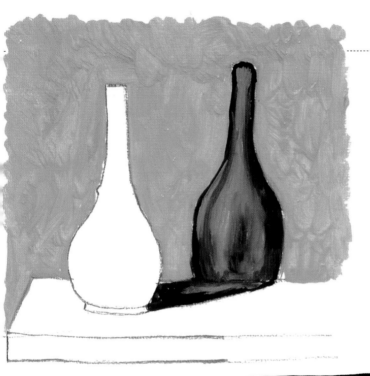

The shadow projected by a glass object requires extra attention. *Since it is not completely opaque, the interior of the shadow has light areas.*

The shadow of glass has a dark edge, *but there are spotty, lighted areas within it that break up its uniformity, and its color is not very intense.*

Painting Darkness

Darkness should not be seen as the negative result of a lack of light, but as a positive; that is, the arrival of a dark mantel to replace the light. This obliges the artist to illuminate the scene starting with the darkness, painting the effects with a restrained palette of blacks and grays, since the darkness obscures most of the textures, superficial details, and chromatic variety of the objects.

In watercolor painting, blue is used in place of blacks and grays.

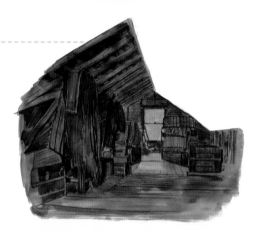

In tenebrist painting, darkness creates a dissonant scene. The objects can be perceived thanks to the soft contrasts created by the light of the candles.

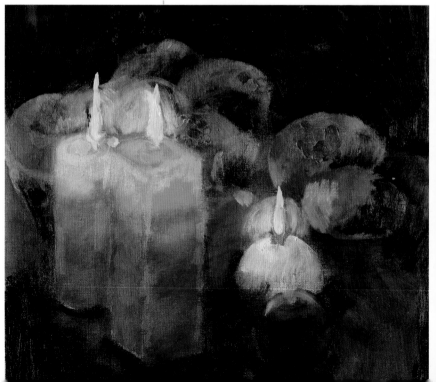

Extinction and Intuition

Darkness can be understood as either the extinction of the intrinsic light of an object, or as the effect of luminous objects being hidden by darker ones. Thus the object, instead of being clearly visible, is merely suggested by the small tonal contrasts that are produced in the dark. In these cases the light should never be white, but quite attenuated, darkened, and with little contrast. This way, the softly lighted zones stand out because of the surrounding black background.

Tenebrism

This refers to a radical version of chiaroscuro, in which the central figures of the subject are slightly illuminated on an overall dark background. The darkness that controls the subject is challenged by a tenuous source of light, normally a small distant lamp or candle, which in many cases is included within the scene of the composition.

Darkness is painted not just with black. *The results are better when a wide range of grayish colors in medium and dark tones are used.*

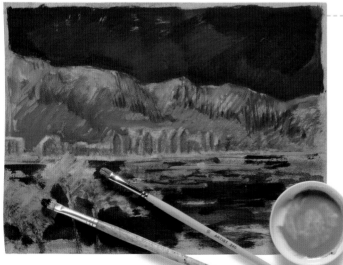

Tenebrism is not only seen in still lifes and interiors; it can also be present in a night landscape with no artificial light sources.

Painting Light

In this last part of the book more attention is paid to representing light in its physical essence. Occasionally light, independent of the shadows, acquires great importance in a work, especially when rays of light, highlights, and reflections are necessary and play a key role in the structure and composition of the painting. We will attempt, therefore, to look at the physical configuration of light in order to represent it correctly, and to try to make visible the effects of bodiless luminosity. The quality and coloration of the light can take on an infinite number of different forms—each of which has a specific effect on the final result of a painted scene, and therefore on our perception of it.

Light Deconstructed: Rays and Photon

Sources of light, whether natural or not, are often represented emitting rays with a theatrical yellow appearance that is very different from daylight. They come in a wide variety of gradients and textures and have the appearance of a uniform surface replete with small brushstrokes. This texture gives the effect of a thermal vibration that causes rays of light to shine.

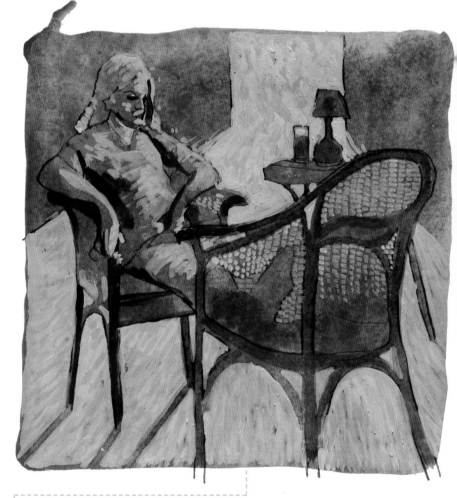

The light that enters the room through the window in the background is depicted in the painting as little radiant light bulbs. Each one of them is made with a whitish brushstroke that transmits the vibrant effect of the illuminated atmosphere.

Particles of Color

Why do some artists paint with small points of color as if they were photons or particles of light? The explanation can be found in our retina. We know it contains three kinds of cells (characterized by one of three different pigments) that are light sensitive: one absorbs the red light of the spectrum, another the green, and the third one blue. Obviously, light photons cannot really be painted, but this treatment using small brushstrokes simulates the effect.

Photons of Light

The energy of the light rays that fall on a material possesses miniscule photons. These can be represented with small brushstrokes of colors, or with light-colored, long, thin lines applied in a linear, radiating way. This gives the effect of photons being emitted from the light in all directions, dragging along small particles that belong to the illuminated body. Light becomes visible because of its innumerable vibrations.

Light is transmitted in the form of small brushstrokes that aim to reproduce the photons expanding in a radial direction.

Streaks of light emitted by colored sources can also be represented graphically, here using a more gradated effect.

Each brushstroke posseses a unique value of light and color. All these representations tend to imitate the expansion of light, to offer a solution to the absrtact aspect of luminosity.

Georges Seurat
(1859–1891)

The oil paintings of France's Georges Seurat are the fruit of long reflection on the conditions of light and the theories of Tomas Young, Herman von Helmholtz, and especially of

Rear View, 1887
Seurat did not construct the body of the model with lines and shading; he concentrated on tiny dots of light that reflected the skin tones. Here, the light creates an optical mixture instead of the traditional chemical mixture.

Seurat very carefully and scientifically studied the decomposition of light into countless bits of color.

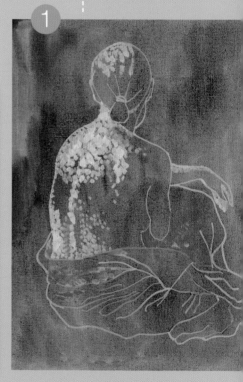

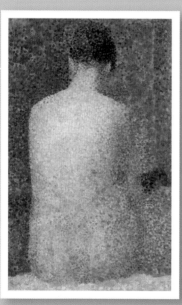

1. This exercise by Gabriel Martin shows how Seurat worked. The outline of a figure from behind is drawn on a background of brown thinned with turpentine. Using very light pinks and oranges, small dots of light are applied to the most illuminated area.

French chemist, Michel Eugène Chevreul. One consequence of his scientifically based aesthetic concepts was his break from the Impressionists to pave the way toward a new style. In the beginning he called it "Chromoluminarism," the representation of a model based on small dabs of color or in pixels of light. In Seurat's paintings, brushstrokes and lines disappeared. The artist concentrated on representing the vibrations of light on surfaces by accumulating small photons of shimmering color. This technique is known today as Pointillism.

THE VIBRATIONS OF LIGHT

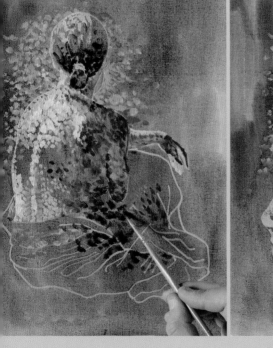

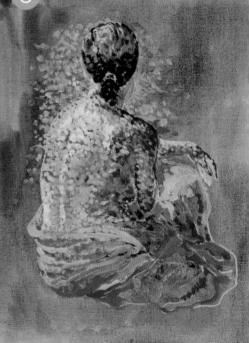

2. *The flesh tones are complemented with medium tone pinks. The background is illuminated with a pair of very saturated blues. The shadows are worked with burnt umber. Saturated brushstrokes of red and cadmium orange are applied to the towel.*

3. *The flesh tones on the back are completed, marking the line of the spinal column and the protrusions of the shoulder blades. The hair is completed with two tones of brown.*

Blinding Sunlight

Frequently, especially when painting a landscape, the intense, blinding light of the sun is nearly imperceptible. The only way to reference it is by painting the things that the sunlight produces: for example, very dark, contrasting shadows or extremely colorful plants that are exposed to the light.

Cloudy days reduce the brightness of colors; they lessen the weight of the shadows and soften the differences between colors. This scene illustrates a grayish harmony.

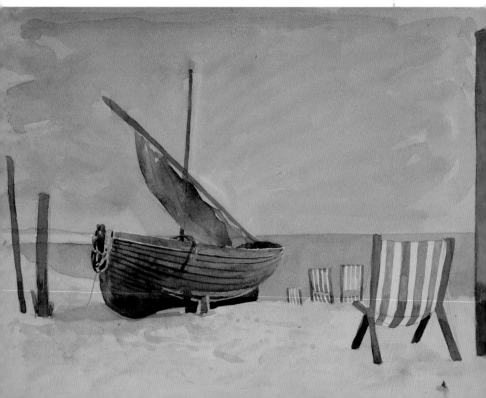

From Cloudy to Sunny

This very informative exercise shows the importance of shadows and colors when expressing the incidence of the direct light of the sun. First we paint a scene bathed in weak light, typical of a cloudy landscape where the shadows tend to disappear, and in which the colors become grayer and less saturated. Then we go to work over this painting, modifying it with new, more saturated colors so that in just a few brushstrokes the picture represents the opposite sort of day. What emerges is a beach scene bathed in a strong, warm light on a summer day.

Contrasts and Shadows

The sky and sea are repainted with blues that are more saturated, typical of the sunny day we are going to illustrate. Nothing emphasizes light more than shadows themselves, which spread across the beach in violet tones that strongly contrast with the light yellow of the sand. The bright white of the sail on the boat contrasts with the grayer areas of the folds. This white is also present in the canvas chairs, and a little is even added as highlights on the sand.

Warmer tones of pink are added to the sand, which will contrast with the dark violet shadows.

Notice the difference between the images on these two pages—one on a sunny day, the other on a cloudy one. In them you can appreciate the need to use shadows to express the greater or lesser incidence of light in each view.

THE SUBJECT

White on Dark

Is it possible to paint with light, and not include a single shadow? The answer is yes if the artist begins by covering the background of the support with a layer of dark paint. In this way the light can be used to make objects emerge from a background hidden in darkness.

__Before starting to paint on a dark background__ it is important to make some samples with simple models. You only have to situate the illuminated areas and the elements will become visible.

__Painting white over darkness__ does not mean that the paint has to be thick and opaque. On the contrary, different kinds of applications should be used to develop different levels of light and various textures.

__When you look at a painting that represents light on a dark background,__ you get a distinct impression that the elements you notice have emerged from a state of non-being, like ghostly representations.

Appearances and Disappearances

When the darkness is so dense that it provides a nearly black background, the artist can make objects appear using strokes of light that emerge and contrast with the dark surface. Thus the model appears from ghostly layers of washes that infer the presence of the painted object. It is like a process of appearances (of light) and disappearances (of dark), the latter hidden under a layer of completely flat, homogenous color.

Painting on a Dark Background

For professional artists, painting on a background prepared with dark paint is rather common. It is a good practice when studying the process of illumination. One must paint only the light and avoid making use of any shading techniques, since the shadows will be represented by the dark spaces that are left unpainted. The light colors can either be painted with thick dense paint, or with light glazes that can create a greater variety of intermediate tones and different gradations of light.

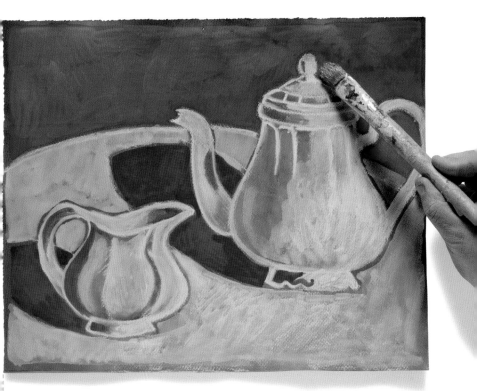

When creating elaborate compositions, it is a good idea to choose paper with medium or dark tones. Here the light is represented only with white paint on a blue background, which is later contrasted with a saturated red in the upper part.

Light on a Dark Background

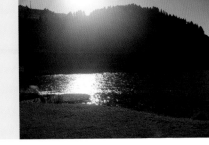

The model is a landscape with a strong silhouette. The rising sun is blinding and creates a strong reflection on the water.

1. The support is completely covered with a mixture of burnt umber and a small amount of black. Acrylic paint is used because it dries quickly. The sky is painted in light blue with thick oil paint.

2. The blinding light of the sun in the sky above the mountain is represented with drips of blue paint heavily diluted with turpentine. The water in the lake is then painted with a mixture of cobalt and cyan blue. In some areas the paint is somewhat transparent.

3. A few small, dark areas are created by using the edge of a cotton rag to wipe the paint on the lake while still wet. The vegetation is painted with a mixture of permanent green and yellow, using vertical brushstrokes to suggest its texture.

Shading is the usual way of recreating the effects of light; however, there are other ways of representing light, like working on a background previously darkened with dark brown. Washes of light colors can be used to represent the illuminated areas. This will allow you to pay closer attention to the way light acts on a particular surface.

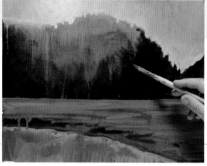

4. A new gradation, from white to blue, is applied to the sun. This way the sun's intensity is strengthened. The silhouettes of the trees are also outlined with blue.

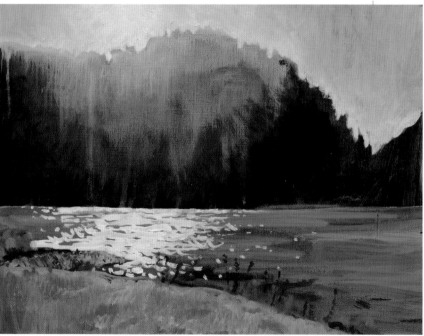

5. The reflections of the sun on the surface of the water are painted with pure white, using a fine round brush. On the foreground, the vegetation is suggested by vague and faded vertical lines. Exercise rendered by Gabriel Martín.

Representing Artificial Light

Artificial light is cast on objects by electric lighting and street lamps. Typically, they strongly illuminate everything near by, leaving more distant planes in a weaker light. They create a theatrical look that is very much removed from the natural feel of daylight. Artificial light alters the true appreciation of the colors of objects and creates quite dark shadows with few tonal values.

The expansion of artificial light is indicated with a gradation based on the lightest color (in the center) moving towards the darker ones (on the outside).

The source of light is represented with a nearly white color, while the gradation is accompanied by thin brushstrokes suggestive of rays of light.

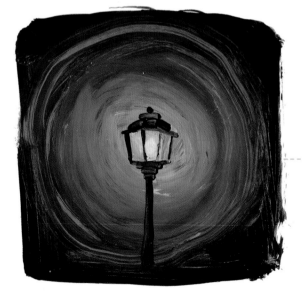

After the concentric gradation of colors is developed, the shapes are painted over them to complete the representation.

Controllable Shadows

The shadows created by artificial light are flatter and darker than those created by natural light; however, they are easier to control because they lack some of the intrinsic qualities of natural light. These include variations in the kind of light, fluctuating intensity due to diffusion and reflection, alterations in color caused by different layers of the atmosphere, and the filtering effect of materials in nature such as plants, leaves, etc.

How Light Expands

When a light source is painted within the composition of a work, the light source is first indicated with the lightest color. Then the beams of light become progressively gradated as they expand from the center. The final result is a circular halo that is gradated like an aura.

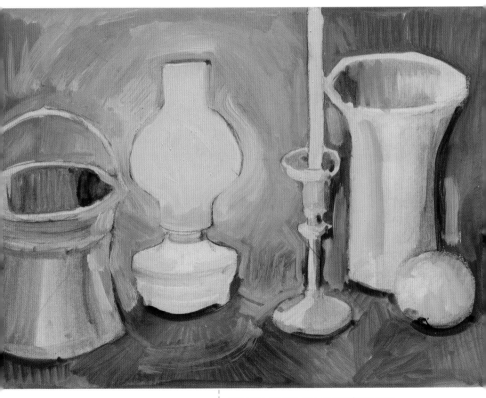

Electric lights are sometimes too intense; surprisingly, instead of illuminating the model, they wash it out. Sometimes they even outshine the sun.

Highlights and Bright Light

Highlights or points of light refer to the areas of greatest illumination— they are the part of the illuminated object that is most active and directly impacted by light rays. Highlights tend to attract the viewer's eye. Like shadows, they contribute to the creation of volume and they help express the texture of a surface.

The highlights should be the lightest color of all the colors in the representation. They are typically small, often just points or dots.

Bright lights are areas where the light is much more luminous than the surrounding tones. This creates a counterpoint or contrast of light in the painting that has its opposite in the darkest shadows.

Reflections of Light

These highlights are light in color and contrasting, and are applied to make some parts of the object stand out by adding light to them. They originate as reflections of the light source on objects that have smooth polished surfaces. Some are as intense as the original light.

How to Create Intense Highlights

An object looks bright to us not only because of its absolute brightness, but because it surpasses the average brightness established for its placement in the picture. The greatest amount of light is produced by objects that are placed in the darkest surroundings. In other words, if an object is very light the reflected light is barely noticed. On the other hand, if the object is of a medium or dark tone, the reflected light will seem very bright and intense.

For reflections to be effective, the model should be painted with a range of medium to dark tones. If the subject is painted in a blinding light, reflections lose their impact because there is not enough contrast.

Are reflections always white? Many artists believe this to be true, but they are mistaken.

Each object, according to its color and material, acts as a mirror for the reflections, and therefore projects some of its own color in the highlight. This means that a red pitcher will have a reflection that is slightly pink.

The shape of a reflection is not simple or uniform; it usually will have gradations with an irregular outline.

Reflections of Light on Water

The model is a fishing boat tied up in the calm waters of a port, with its reflection projected on the rippling water.

1. *Óscar Sanchís starts with a very simple sketch using an HB pencil. Then the first contrasts are painted in with ultramarine blue that has been diluted with turpentine.*

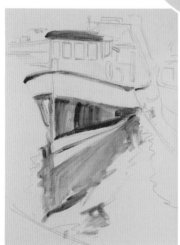

2. *More opaque paint is applied over the previous application: a medium gray and bright yellow on the boat, and a gradation that goes from ultramarine blue to permanent green to represent the reflections on the water. At this point, the details are left out in order to paint freely with general brushstrokes.*

3. *Great attention is paid to the surface of the water. The illuminated parts are covered with two tones of thick, light violet paint that can be easily blended together. New effects are then painted with zigzag strokes of titan blue.*

The impact of light increases when a surface of water is included in addition to the shadows, since it acts as a large reflective area. Water, like most liquids, captures a lot of light: it holds it, interacts with it, and casts it out towards the surrounding elements, creating interesting shapes and surprising chromatic effects. It produces thousands of small reflections when touched by the sun's rays, and because of this water can even change the atmosphere of a scene and the look of any nearby objects. The following exercise was done with oil paint.

5. For the reflections to be convincing, the brushstrokes should be firm and the colors should blend on the surface of the painting. The upper part, where the other boats are visible, is not complicated since it was simply given a loose, sketched treatment.

4. Brushstrokes of blue are applied to the illuminated surface of the water, dragging some of the previously applied paint which is still fresh. A medium green is used to throw some light on the dark reflection of the boat. Be sure that the edge of the shadow has a jagged outline to represent the rippling surface of the water.

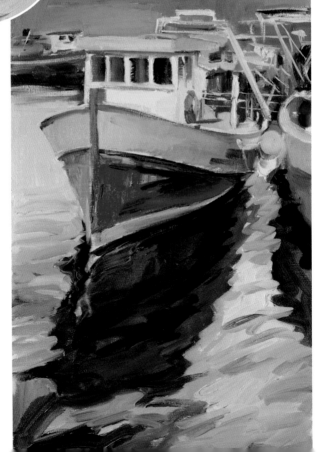

EFFECTS

Different Reflections for each Surface

Highlights transmit a feeling of smoothness to the surface that reflects them. However, there are different kinds of light in reflections as well as different kinds of reflections that depend on the material they

The highlight on an eggplant should be made while the black paint is still fresh. First apply a stroke of white. Then, with a dry brush, blend the edges of the brushstroke with strokes in the same direction.

On a copper pitcher, the highlights have an orangey tendency because of the color of the material. Since they are on an irregular surface, they are applied with dots or dabs using a medium round brush. The paint should be thick and creamy.

appear on. Understanding their intensity, shape, size, color, and how they are integrated with the object will help you differentiate these various kinds of reflections and easily resolve them. The rest depends on the artist's ability to express the form and the effect produced by each highlight. Let's look at a brief lesson and try to study the different kinds of highlights that we can find here.

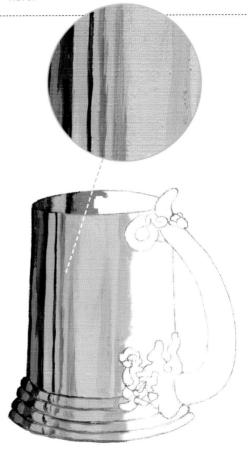

The reflections on glass are more difficult to control, *since their colors depend on the color of the light as well as the colors of the background. If it is a tinted glass, the reflections will always be white tinted with the glass color.*

A polished metal mug shows very clear reflections. *These objects become reflective surfaces with clearly delineated tonal areas in the shape of vertical bands. This is one of the few cases where reflections can be pure white.*

Theatrical Effects of Reflected Light

The rear wall and chair receive the direct impact of the late afternoon light. This turns them into a new source of light which radiates energy on the rest of the elements in the model.

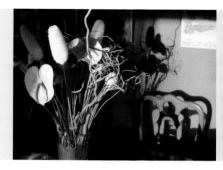

1. *After making a very simple and stylized pencil sketch, the whole paper is covered with a wash of magenta and orange paint that matches the dominant colors in the model.*

2. *The wall is completed with new acrylic washes of red and violet, reserving spaces for the dried flowers in the vase. The first contrast is added when the table is outlined in black.*

3. *The flowers are rendered with thicker, lighter paint. Since the zone is very well lit, the dominant colors will be yellow and orange. The treatment is somewhat stylized.*

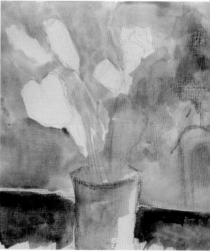

THE EFFECTS OF
REFLECTED LIGHT

Reflected light is that which is generated from another nearby body or object and becomes a new source of less intense light. At the same time, it generates new reflections and new shadows on the object that is being drawn or painted. This reflected light can never be as bright as the original light source, but it adds a dominant color to the whole that can be very interesting. In this exercise Glòria Valls uses acrylics to illustrate this curious effect of reflected light causing new layers of color on the darkest areas of a model.

4. *When the first round of washes has dried, the shadows of the vase and the back of the chair are drawn on the illuminated wall. A wash of black mixed with violet is used for this. The same color, but thicker, is applied with a spatula to paint the table.*

5. New violet colors are used to progressively darken the background. The stems of the dried flowers are drawn with a round brush, alternating light ocher with a range of greens slightly tinted with orange. The lines are made with single strokes.

6. Using a lighter and more opaque orange, the back of the chair is painted to look like it radiates light. For this to work effectively, the object must be much brighter than all the surrounding colors.

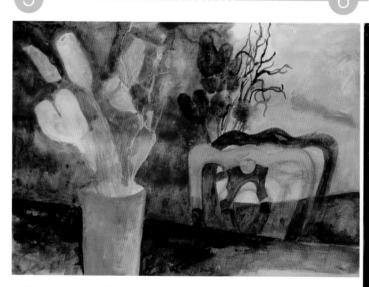

7. The intense frontal lighting, coming from a large window, creates a well-defined shadow on the wall and makes it the center of attention. This shadow is emphasized with washes of black paint mixed with a little violet or blue—colors that strongly complement the orange paint on the chair.

8. The reduced palette of warm tones is based on the light of the late afternoon sun, and is emphasized on the wall and back of the chair. The reflected light alone is responsible for the appearance of redder tones on the table and glass vase.

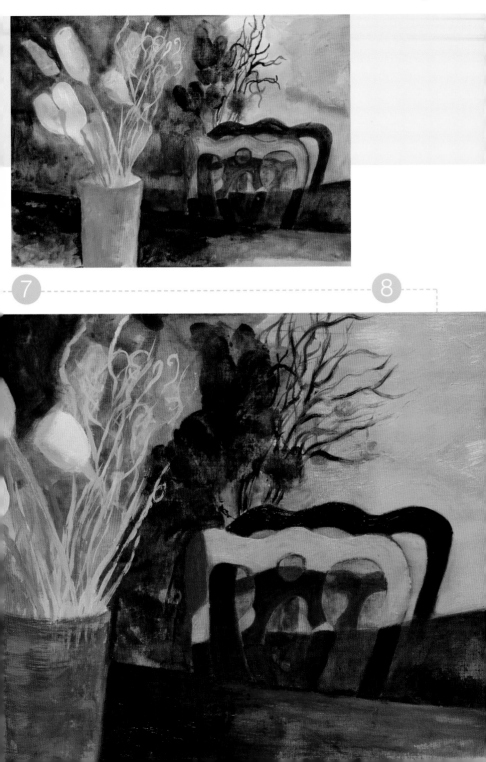

Night Scenes

When the sun is hidden by the horizon, street lamps and the lights of businesses take over and illuminate the urban scene. This varied and attractive play of colored lights is a subject that offers the artist many possibilities for different, interesting effects. Using a few simple notes of color we will illustrate some concepts about the treatment of darkness and spaces illuminated by artificial light. These are

Here the color black will not be used. *Dark variations obtained from mixing dark ultramarine blue, alizarin crimson, and sap green are used instead.*

There are two options for painting the facades of buildings: *light the lower part and darken it as you move upwards, or apply the gradation as you move downwards. In both cases the color of the sky (light or dark) will be important for distinguishing the upper edge of the building.*

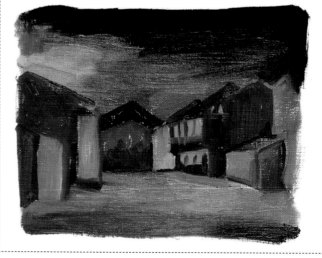

Begin with simple scenes. *The main goal is to resolve the gradations on the facades by mixing various colors with black. Stylized work will allow you to better concentrate on the different planes of light and dark.*

useful techniques for addressing a subject where representing architecture is the main task. Tackling urban scenes with streets and illuminated buildings is one of the main attractions of painting night themes.

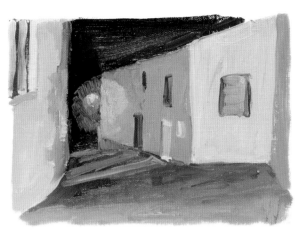

The next step is adding an artificial source of light to the scene. The walls of the house are painted first to create the most appropriate atmosphere. The light source is incorporated at the corner, forming a clear gradation with yellow orange.

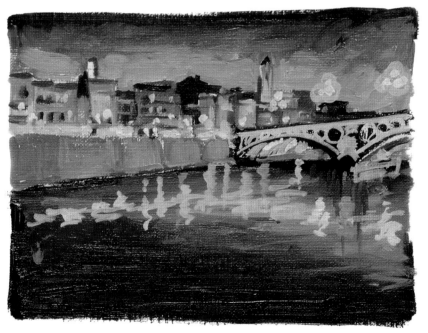

Now you can attempt to address more complicated and daring representations, with several artificial light sources and reflections. First the light is painted on the facades with gradations, and then the points of light are superimposed using thick, light paint.

Odilon Redon
(1840–1916)

French Symbolist painter, Odilon Redon, attempted to break through the limits of painting and immerse himself in the world of fantasy and dreams.

Beatrice, 1897. Color lithograph (private collection, Madrid).
Redon was greatly interested in heads with closed eyes, lost in intimate contemplation. His work opened the door to a concept of light and color that was unique in its time. The strength of Redon's style lies in its subtlety, vagueness, and lack of definition that requires a docile submission of the form to a blinding light that invades the picture. There is so much light surrounding the face of Beatrice that it is evanescent to the point of becoming an abstract work of art.

Odilon Redon was interested in the more spiritual side of the phenomenon of light.

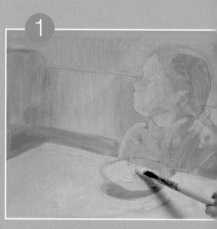

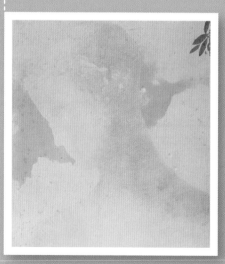

1. *In this simple exercise Gabriel Martín tries to reproduce the luminous atmosphere of Redon's work. Layers of very light blues, greens, and yellows are applied to the drawing. The background of the drawing looks like a wash, while the rest of the painting has thick brushstrokes.*

2. *The table is painted with white to which was added a touch of green, and the area around the figure is lightened so it can be somewhat visible. The paint is quite thick and the brushstrokes can easily be seen. Using very light violet the girl's hair is darkened and her face shaded.*

He did this by changing the forms, the color, and above all by modifying the light, which he related to the spiritual world. Although in his drawings, paintings, and prints he started out studying the nature of light and contrast through deep solid blacks, he later began using saturated colors whitened by a light that floods the space. He favored the transparency of a blinding atmosphere where objects seem to emerge from behind a curtain of light. His shadows are washed out by light, and his extremely subtle contrasts make an object's surroundings barely visible.

3. *Two wide bands of gray are painted across the background wash. New orange and ocher values are added on the girl's forehead. There is barely any contrast since all the colors give way to the lack of variation among the different shades of white.*

4. *A fine round brush is used for the final touches. The face is given a small amount of expression and texture is added to the locks of hair.*

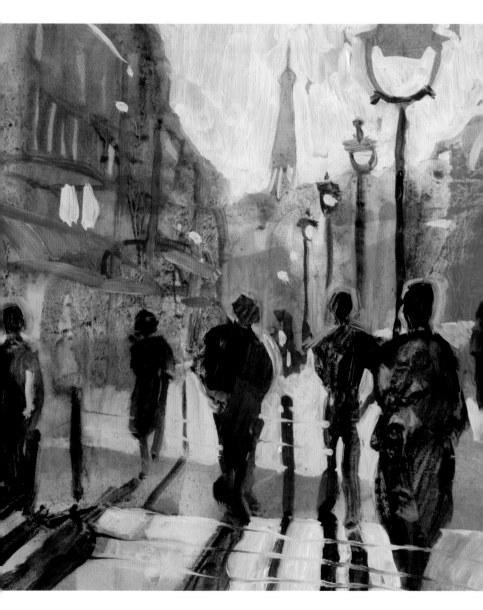

*"Always take note of the brightest light of the place (where you are painting);
study it and follow it systematically, because if your work fails at this,
it will have no relief and will end up being a simple thing showing little skill."*

Cennino Cennini